Managing Editor/Editor-in-Chief: Connor Bowen

Cover Art: Cushon Crump

If it Hadn't Been Zachary Ross	1
Pocketwatch Lexi Klonk	2
Venom Anonymous	3
Seashell Danica Bickley	5
I Laugh, Even Though I'm Not Supposed To Will Gibbs	8
Heartache Jenni Bowen	9
Mustang Graveyard Kate Burford	10
Grad Party Annie Bowen	26
Flamingos Eye Erica Mirth	30
When a Whisper Fell Christopher Zilwitt	31
Douley's Bar and Grill Austen Duke	32
Garden Jazzy Hernandez	35
A Clearing Erika Williams	36
Cadaver Stephen Bowen	39

If It Hadn't Been

Zachary Ross

we smash
into darkness and sparks fly
ringing isn't the word for it

but its too much to comprehend
and you get out
and I sit there

stunned? maybe
because you crashed your car
and brought down an entire street's electricity

and you have a child
and now
you have eight thousand dollars that

you owe
I sit in your chevy equinox
with a bruised shin

owing nothing
feeling like I owe everything
to you

it was my destination
it was my chore
it was my potential profit

your loss
and you blame me
finally, you blame me

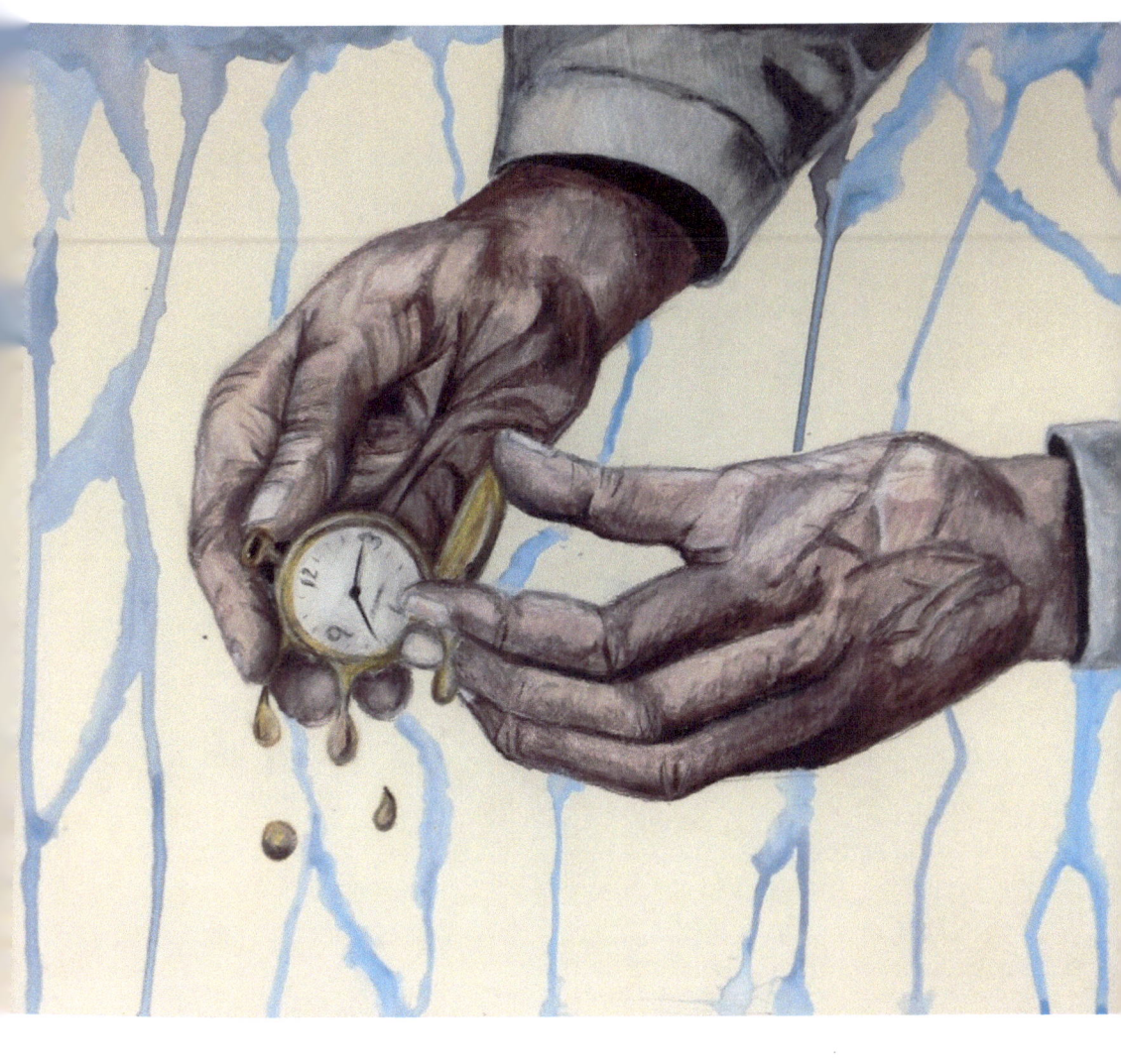

Venom

Anonymous

Our last touch was her clinging to my shirt with tears in her eyes. Tears that bled desperately for an answer as to why. All she wanted was truth, but I couldn't even give her that. I pulled away. "Go inside." I tugged harder but she tugged just as hard. "Connor go inside!" I unclenched her fist from my shirt and I was free. I just didn't know whether I wanted to be. She continued to fight, as he forced her further toward the steps. She didn't call my name, she didn't say a word. She reserved her effort for one thing; to shake the obstacle that separated her from love. The obstacle that knew this toxicity too well; that had tasted it before. To me- I enjoyed the flavor. Perhaps because it was the only elixir that had ever touched my tongue. It was warm and luscious, but it had been snaking its way down my throat for months now and was soon enough to be in my belly. From there, not even my naivety could conceal the poison's sting.

Thud

I turned to see the limit of desire as she slowly stood up, tears pouring now. The others' hearts softened as they came to her aid. None of this was intended, but she was the one with her hands on the wheel, foot on the gas, stepping down harder as the engine red-lined, veering left and right as rubber screeched across pavement. She had driven down this bend before and thought that she knew the road, that it was rough and tacky. She hadn't felt the rain that fell hours before making the asphalt slick and unpredictable. It

even tried to warn her; it glistened in the moonlight, but she was too focused on her destination to see the road.

She walked off of my porch with only whimpers left to expel. She had lost in her strive for happiness, for answers, for comfort; for everything pleasant and warm. For me.

My love had fallen to the ground at the hands of my friend. So many emotions wrestled inside of me, but relief was the one that prevailed. *Another man had thrown my love to the ground and all I could feel was relief!* I needed to regurgitate this venom and escape this deadly sickness. I closed the door behind me and poked at my uvula. I knew it would be some time before I would vomit, but I couldn't even gag. Maybe the poison had made me numb. Maybe it wasn't poison, after all, it did taste so good.

Seashell

Danica Bickley

"Ready, set, go!", your dad's voice echoes through the deserted gravel alleyway. It was right in front of your yard and trees, giving it an almost magical, secluded feeling, surrounded the other side. As you break into a sprint, your legs start to go numb from movement. You had to win. Your little sister always beat you and you had to win just once.

Barely noticing a protruding rock in the path, your feet are knocked out from under you. Your body collides with the ground as pain spreads throughout your body. Your knees burn and you can feel the pieces of gravel lodged inside them. The taste of salt spreading throughout your mouth, you can already tell you'll be missing a couple of your teeth. What hurts the most though, is your right hand.

You bring it to your face slowly, studying it. There is a small seashell lodged into your right palm, blood spilling from it. Your vision goes fuzzy, like someone placed wax paper over your eyes. Your dad is shouting but you can't quite make out what he's saying. His words are distorted like your head is underwater. It feels as if there is this ball of warmth spreading it's way through your entire body, starting at your fingers and toes and moving it's way up to your face and ears. You barely feel your dad lift you as you finally give in to the heaviness encasing your body.

When you pass out, the first sense to come back is hearing. A thing you can attest to from the numerous times you've woken up to the monotonous beeping of hospital machines. Though you're aware of this fact, it never seems to be any less terrifying.

You debate whether or not to open your eyes for a few minutes, finally peeling them open to re enter the world. The first thing you see is your dad, head buried in his hands.

"Where am I?" you ask although you already know the answer.

"The hospital, you fell and passed out." He answers, eyes full of worry.

When you pass out, your dad always plays the concerned father role. He's gotten so good at it you almost let yourself believe it for a minute. But you know all too well, what the truth is.

You examine your bruised body, taking in how small and frail you look, the oversized hospital gown draped over you like a sheet over a corpse. You pull the gown up past your knees to observe the bandages wrapped around them, patches of scarlet in the center where blood has seeped through. Running your teeth along your gums, you notice 2, no 3 new missing gaps. Finally, you lift a shaky hand to your face to reveal clean stitches curving the letter "C" into your palm. You feel your head go light yet again at the sight of it. Just as you're pulling yourself together, your mom rushes into the room.

"Are you okay honey?" her voice cracks on the last syllable. It's this small detail that tells you that you probably look a lot worse than you feel. You nod as your dad lays his hand on her back to comfort her.

When you pass out, your parents almost make you believe they still love each other. They almost make you believe your family isn't shattering before your eyes. An illusion that passes the moment you get home.

Your parents follow you into the house, walking closely behind you just in case you faint again. They always do this; treat you like you're so fragile you could snap at any minute. Maybe you are, but not because of this.

You turn around to face them, "I said I'm fine."

You're tone is much colder than you'd like, but it seems to get the job done as they retreat to the family room. Finally, you rush up the stairs to your room and shut the door swiftly behind you. You hit play on your stereo, letting the last song you'd been listening to play through. Your entire body shakes as if there is a volcano in the pit of your stomach, preparing to erupt. You bite your hand trying to contain the sobs attempting to escape your body.

When you pass out, you allow yourself exactly twenty minutes to break down. Twenty minutes equates to an average of five songs, the length of a sitcom on cable television with the commercials taken out, or the maximum length of a panic attack. Twenty minutes, before you pull yourself together, open your eyes, and face the world.

Picking yourself up, you walk over to the clear bag of your belongings you'd brought back from the hospital. You sift through jacket, headphones, phone charger, and some papers to find what you were looking for. You press it to your unharmed palm marveling at how something so small could do so much damage. You close your hand around it hard until you feel the sting of skin breaking. Slowly you open your palm to reveal a small seashell and blood dripping from your palm.

I Laugh, Even Though I'm Not Supposed To

Will Gibbs

I realized it was over while riding the rollercoaster.
That sluggish climb up the rickety hill
Was how it felt to be with you.

Stop. Start. Stop. Start.
Click. Click. Click. Click.

We screamed and laughed on the way down.
At the bottom you looked over and smiled at me.
I smiled back.

But I wondered when we would fall again.
Not on the chipped, orange metal tracks,
But when we would be done.

After the ride, an old woman said we look like a cute couple.
You with your brown curls
And me with my white teeth.

She said she could tell we're in love.
How could she tell that when I was certain we weren't?
You said thanks and we walked off without speaking.

And you knew it.
And I knew it.
But we didn't talk about it.

Instead we talk about the pink and orange smearing sky
And how it's hot.
Like the time it was 100 degrees at midnight and we sat outside
On the manmade beach and got too high

Talked about the future and the past while we sweated.
If we would stay together
Or if it would end like the rest.
So we stopped.

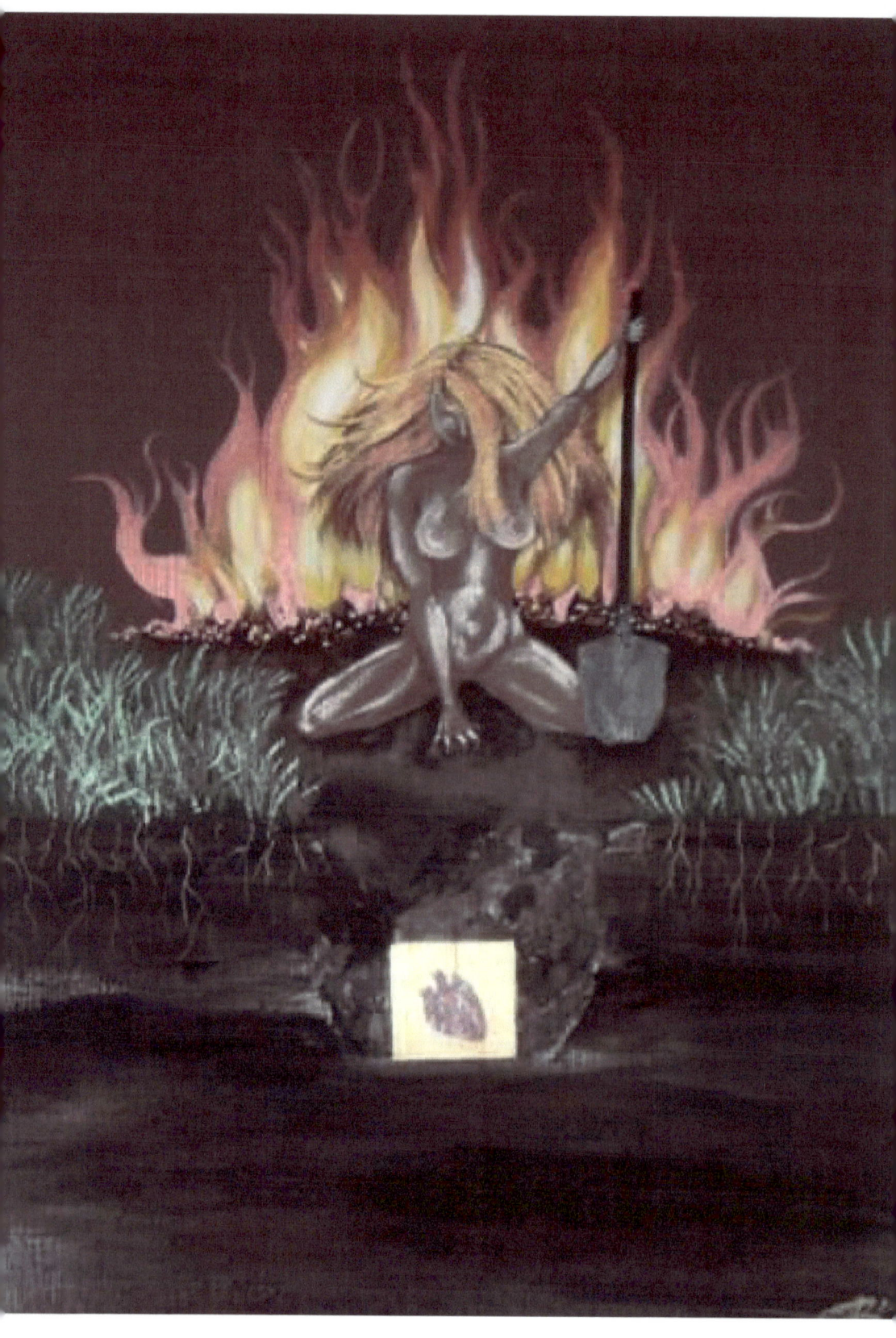

Mustang Graveyard

Kate Burford

66 Lewis Ave.

Ash Fork, AZ 86320

November 5, 2010

Ms. Penelope Wilson,

You don't know me and I don't know you, but I'm pretty sure I hate you. This is just a hypothesis, of course, but I'm under the impression that you treated your brother like a disease rather than a person. Most people do.

Did his death make the press all the way over in Michigan? I hope this isn't your first time hearing that Neil's dead. I would give you my condolences, but it disgusts me to think that you probably didn't even consider him human. He loved you *to death* and you should be ashamed of yourself for cutting off contact with him and leaving the messy aftermath of how he felt about that for me to deal with. Thank you so much.

I hate doing this, but you deserve to know who your brother was beyond his "disease". First things first: I swear to the deity of your choice that I didn't murder Neil. He didn't kill himself, either. Blame horrible luck and ill timed prescription drug side effects kicking in if you have to blame something. Blame the disease.

You probably need to know a bit more about me before you start jumping to conclusions. It takes real skill to be as terrible at my job as I am, Neil always would say.

I've never done anything spectacular as a court investigator, and the only reason I even got into the field was a freak accident college film project.

I nested my camera in my window overnight to record the sunrise, and when the sky began to tease yellow, two figures dived into the shot. One of the guys starts beating the hell out of the other guy until he slumps over, unconscious. The guy mugs him and takes a few looks around before sprinting away from the scene of the crime. Even though I accidentally recorded decisive evidence of a mugging, I only got a C on the project.

That was one of the only times I ever got lucky in my entire life. I grew in Michigan, just like you, and I'm pretty sure the epitome of my atrocious luck is rooted in the string of Detroit-dwelling Daniels I've dated:

Exhibit A: The first Daniel was one of those boyfriends you just have to gloat about. I was in high school at the time, and *everyone* knew that I was dating Danny, the college boy. He got along with my family well. I met him through my brother, who went to school with him. Danny and my brother would hang out at my place practically every day while I was at school. After an over-dramatic performance for the school nurse one time, I managed to weasel my way out of class halfway through the day. I thought I would surprise Danny by being home early, but I ended up being the surprised one when I found him heatedly making out with my brother on the couch.

Exhibit B: I met the second Daniel at a costume party where I was a sunflower and he was a pirate. We were equally smashed when we hooked up. He laughed

like a suffocating pig and could have easily passed as a small grizzly bear. Turns out he was the manager of a chocolate shop downtown and was arrested on charges of trespassing and robbery.

Exhibit C: Dan, the third Daniel, had a greasy black mullet that he shaved off when he joined the army. He kept his creepy mustache. Every time I ever saw Dan, he was high as shit and his t-shirts were always stained with something gross. When I gave him the choice between me or the weed growing in his windowsill, he easily chose his precious mistress, Mary Jane.

You'd think I'd have enough sense to avoid Daniels after all that, or just give up on men entirely. I got lucky again with the fourth Daniel, Neil. You two weren't in contact when I met him, so I'm not sure how much you know. We married after two short years, and I truly loved him.

When Neil popped the question, it was the least romantic thing I ever heard in my life. He got down on one knee and said, yo, marriage is a social construct but the benefits are totally sweet. Like, we can file joint tax returns and neither of us will end up dead in a ditch somewhere since we can pre-arrange our funerals and stuff. And hey, we'll go live in my dead grandma's house in Arizona.

But you have a job here, I probably said. To which he snapped: dude, I'm getting the fuck out of Detroit whether you come with me or not. This place blows.

My name that day onwards was Lily Wilson. I moved into your late grandmother's house in the barren outskirts of Ash Fork, Arizona, where we met our

children, three obnoxious cats. Neil might as well have been one of the cats, from how skittish and unpredictable he was. If anyone set foreign foot on our property, he would grow quiet and tense. At least he didn't line the front porch with dead lizards.

Turned out that Neil wasn't the one who had problems finding a job in Arizona; he easily found a job at the salvage yard a few miles away from our house. I've read enough Sherlock Holmes to have my romanticized version of detectives crushed by reality. Instead of tracking down crafty murderers or solving mysteries of phantom hounds, I often found myself settling dumb marital disputes and falling asleep over law books, law books, and more law books.

Back to Neil, though. Neil was a great guy, but as you know, there was something seriously wrong with him. Of course I know what his *diagnosis* was, but Neil hated being labeled as a disease and I didn't blame him.

One of the scariest parts wasn't the *diagnosis* itself, but the effects of his medications. He took so many pills that I constantly feared he would explode or something, a human flask in a chemistry experiment.

I know you've seen those cheesefest TV ads for allergy medicine. The ones with smiling actors prance through fields of daisies while the narrator pleasantly reads off an extensive list of excruciating ways the medicine can slowly kill you—but hey, you won't sneeze around cats anymore! Neil's medicine had even worse side effects, that weren't just a *maybe*. He left the complete list on the bathroom counter one day, and I regret reading it.

Seizures, memory loss (to the point where I feared he would wake up not knowing his own name anymore; though I think this may have been the intended effect of one of his prescriptions), hypersensitivity, mood swings, fainting, panic attacks, dizziness, nausea; pick any side effect, he probably had it. Some of those are probably symptoms of his *diagnosis*, but it was hard to distinguish between the two.

You probably know that studying Neil's *diagnosis* and memorizing his side effects didn't make him any easier to understand. Persistence and warped thinking were the two main components of Neil. It was frustrating as hell.

Here's where you become useful: if anyone in the world could keep their mouth shut, it was Neil. His therapist coaxed me into espionage mode to find out anything about his past, since he never said a word about his childhood.

Neil typically didn't talk about himself at all, but those damn cats triggered him into telling me the same horror story, over and over again (you probably heard it a million times, too). It got so bad that we had to get rid of the cats a few weeks after we moved into the house. The memories were driving Neil mad, but it was also the only time I ever got an earful of Neil's past. I took notes.

Past Trauma / Neil's Approx. Panic Levels (%)

10% — Mother beat the shit out of him. He had to lock himself in his room, hide under his bed with his hands pressed over his ears while she pounded on his door and screamed. The conniving bitch (~~no offense~~ actually, yeah, I meant that) weaseled her way out of the investigation sent by Neil's last

resort of calling Children's Services by raving about how *ill* her poor boy was.

50% — Neil frequently fled to the neighbor's house at night when he was afraid. He'd spend days there. The kind lady next door took care of him like a real mother. She was a sweet old lady who used to scoop Neil up in her lap and dig through the bottom of her bookshelf to dust off old storybooks for him.

Your mother wasn't too happy about this, and warned Neil to stay the hell away from her, not to trust her. That something was off about her ever since she lost her husband.

85% — Your mother slapped you when you came home past curfew.

90% — Neil saw a pregnant cat make shelter in a cardboard box that had fallen out of the dumpster in the back alley beside your house. He took care of the cat, and it gave birth to five bright-eyed little squeakers. Neil never took the kittens inside, but he made sure to leave them food and water every day, and said that the kittens were the only thing he liked about Detroit.

The deep rumblings of a thunderstorm woke Neil up one night. He rose from his bed to look out his window. *FLASH!* The silhouette of someone

outside in the alley. *FLASH!* Holding a knife up, about to stab something. *FLASH!* Kicking and a swift turn.

When Neil fed the kittens that morning, there were only four. They wiggled around, nudging their stiff brother with bloody, matted fur and a slit throat while mamma cat curled itself around him. His limp head bobbed as mamma cat groomed his cold, tiny body. Neil stole a hand towel from the kitchen, wrapped it around the dead kitten, and took it to his room. Mamma cat nearly severed his ulnar artery in the process.

This continued for the couple of nights until all of the kittens were dead. The storm passed when there were only two kittens left, and Neil was finally able to recognize the culprit—the old lady next door, who loved him, was killing his cats! Mamma cat's throat was never slit, but Neil found her dead a week after the little ones died.

110% — You probably don't remember this, but *I* certainly do—Neil was so obsessed with it that it's hard to remember if it's my memory or his. You got into an argument with Neil about 15 years ago over something stupid. The exact words you said: "No one likes you." He panicked over this every single day.

That's all I know about Neil's childhood. Maybe you could help fill in the blanks. Maybe I don't want to know.

Shortly after we moved to Arizona, I forced Neil to go to a diner with me and two girlfriends from work. The girls were chatty and loud and too intelligent, which I realized was my first horrible mistake in dragging Neil along with me.

Neil was a nervous wreck driving to the diner, so bad I had to ask him to pull over so I could drive. "Neil, it's okay." I slid my hand down his leg, surprised at how tense he was. I made the second horrible mistake by saying, "This'll be good for you."

At the diner, Neil was so uncomfortable that it made *me* nervous. He didn't make a noise and desperately stared out the window, considering the possibility of smashing it to pieces to escape. I chatted absently with the girls, but my attention was locked onto Neil the entire time. My third horrible mistake was being considerate and shifting our conversation to include Neil. When one of the girls spoke directly to him, he shot up and ushered me out of the booth, murmuring, "We've gotta go. Sorry."

The fourth horrible mistake was letting Neil drive, and the fifth was asking Neil what happened at the diner on the 87 mile per hour ride home. The question triggered him into raw panic that nearly got us killed. "They hate me they hate me, oh my god, Lily, they hate me. I'm sorry—I'm sorry—I'm sorry!"

If Neil had crashed, the paramedics would have had a hell of a time prying his dead hands from the steering wheel. "Neil! Stop!"

Sixth horrible mistake. Neil freaked out so much that he could no longer form words—and *definitely* could no longer operate a speeding death trap—but at least he slammed on the brakes hard enough to make the car to screech off the road and nearly tip

over sideways. I tried to calm my breathing and pounding heart as I watched the dust storm cloud around the car. Neil hyperventilating tore my attention away from the ground.

It was about ten times more terrifying than you could ever imagine if you've never seen Neil that scared, Penelope. He looked and sounded like he was going to die, and from the looks of it, he thought he was actually dying, too. The seventh horrible mistake happened when I instinctively brushed my hand against his skin in attempts to calm him down.

Neil had never done anything to hurt me before then. He smacked me away so hard that my bruise stayed visible for weeks, and I had to lie about it, telling people that I tripped. I was too stunned to do anything when he fumbled to open the door and roll out of the car. I heard him puke all over the ground and felt hot tears stream down my face. That was the last time I even *thought* about pressuring Neil to go somewhere with me.

Weeks later, I worked up the courage to ask Neil for the second time what happened that day. "It's not fear, really," he said, fidgeting with his shirt, not looking at me. "I just felt like those girls didn't like me, and then it seemed like you were mad at me when we were in the car."

"I was never mad at you. And why? They wanted to talk to you, Neil. They wanted to get to know you."

"That was the problem," he murmured. "I couldn't have them to know anything about me. I love people too much. That's why."

I still don't really understand his answer, and probably never will. I didn't bring it up again, even though I should have.

*

Days before Neil's death, I was surprised to find that he was home before me, still in his jumpsuit, smelling like rust and sweat. Perking up, he ran over to me, not bothering to turn down the radio. "Yo, Lily! I just remembered something cool."

"What?" I asked, competing to be heard over Freddie Mercury. Neil followed me as I discarded my purse on the counter.

"In high school, I used to make *movies*."

"Um, what kind of *movies*?"

"Stupid ones," he said. Neil laughed like he had been shocked by five hundred watts of electricity (he always did; it was kind of cute). I couldn't help but smile as I tried not to breathe in his stench. "Really fucking stupid. Like, I think we did one where there was a time machine—and we filmed it in one of my buddy's basements, a real creepy basement with one of those old fashioned furnaces, you know? God, it was so terrible. Hey, I bet I still got that tape lying around somewhere."

I didn't want to upset him, so I gently suggested, "Maybe that's not the best idea right now. I mean, if you just remembered all of that. Don't get ahead of yourself."

"Whatever. I'm gonna find those movies, 'kay?"

"Can you at least shower first?"

He laughed. "Definitely. Sorry, babe!"

Neil tore the house to shreds looking for those tapes, all in sync with *A Night at the Opera*. During the search, he found a lost earring, several lonely mismatched socks, some of my family albums, and vintage left shoe... but no tapes.

He did, however, remember something else—the name of one of his film buddies. At that point, I was terrified that he got himself stuck in a chain of recalling lost memories, ones that were better left forgotten from what data I'd gathered on his childhood.

We crammed on our overstuffed couch we picked up from the dump while Neil pulled up Facebook on his laptop. At this point, I was too nervous to protest. Carlos Guzman was the guy's name, according to his profile. "Ha! Me and Carlos and the other guys used to sneak out of school and hang out at the sketchy McDonalds across the street. We thought we were so badass."

"Didn't you live on the bad side of town?"

"Every part of Detroit is nasty, babe—I dunno where you thought *you* lived all that time."

Neil proceeded to click furiously through dozens of awkward family photos all the way back to high school. It was mesmerizing, watching the progression of someone getting younger and chubbier with the exact same smile in every photo.

Eventually, Neil stopped and smudged his finger on the screen, forgetting that it was one of my biggest pet peeves. "Yo, hey! See? That's the basement I was talking about. Creepy, right? Place was practically built out of tubes and raw insulation."

I laughed. "Pretty edgy film setting, I guess."

"I know, we thought we were so—" Neil cut himself off and shoved his computer into my lap. He half-sprinted, half-slammed into hallway walls like he'd been pepper sprayed.

My stomach dropped. I discarded his laptop and chased after him. "Neil? Neil!" I only got halfway down the hallway when I heard the door to our bedroom slam shut and lock. Stunned, I knocked on the door. All I got was a strangled sob.

I wound up back on the couch, terrified and having no idea what was going on. Carlos Guzman's smiling face stared at me from the screen of his laptop. I gently picked up the computer and scanned the page for anything that might have set him off.

Cats? None. Deceptive, murderous old ladies? I couldn't draw a connection. Abuse? Carlos looked like the happiest guy on the planet, and had a lot of genuine-looking photos with his family. Forced, painful smiles, so abuse wasn't out of the question, but who doesn't look like that in family photos?

Having no idea what else could have triggered Neil so bad, I came to the conclusion that he probably remembered too many things too fast, something horrible and possibly unrelated to Carlos and the movies he made in high school. Too scared to pound on my bedroom door again, I decided to give Neil his space and fell asleep curled on the couch.

Although Neil crawled out from the nest the following day, he wasn't all *there*. This wasn't anything new to me, but it didn't scare me any less than it had other times he'd been like this. Neil looked like death reincarnated and didn't speak a word to me all day.

When we sat down to eat dinner that night, Neil stared blankly down at his plate. I was nervous and could hardly take it anymore, so I quietly set down my fork and asked, "Neil, um, are you okay? Can I do anything?"

Huge mistake. Neil broke down sobbing. Petrified, I had no idea what to do but stare at him. I wanted to stay with Neil, but my cowardice forced me up from the table. I retreated to our bedroom, leaving Neil to cry alone.

I went to that Carlos's Facebook page again, but found nothing out of the ordinary. He smiled big in his profile picture, holding up a bass bigger than his forearm. Out fishing on a sunny day, alive and well. Trying to figure out what was going on in Neil's head was killing me.

I woke up that night to Neil shaking me like a ragdoll. "Hey, hey! Lily! Wake up!"

A jolt of terror stabbed through me and I was wide awake. "Oh my god, what's wrong?"

"Hey, let's go outside."

My heart settled, but my brow wrinkled in confusion as my tired eyes strained to make out Neil's form as he slid out of bed. "Out...side...?" My hand fumbled around for my phone and I nearly blinded myself checking the time. "It's four in the morning, Neil. Go back to sleep."

Neil didn't care. He turned on the lights in our room and I soon heard the rattling sound of his pills from the bathroom. Neil returned to drag me out of bed, and we stumbled outside clad in grimy old t-shirts and shorts, standing awkwardly on the front

porch where Neil froze. The chilly desert air made goosebumps creep up my bare legs. "Um, Neil?"

"Shhh," he hissed. I followed him around back, wincing as pebbles dug into my feet. Neil brought out the old, rusty ladder and set it up against the house. "We gotta get closer to the stars," he said, so I hesitantly climbed onto the roof ahead of him.

Neil wasn't afraid of heights like I was. In fact, I had never seen him so calm. I clung onto him, feeling his heart beat slowly against me as we sat on the rooftop. He probably thought it was funny that I was scared.

"Neil?"

I felt him tense. "Yeah?"

"What's wrong?"

For a minute, I didn't think that he was going to say anything. "What's wrong *with me*, you mean?"

"N-no! I meant..."

"Hey," Neil started cheerfully. "Remember that time you tagged along to work with me?"

My throat was too clenched up to say anything, so I nodded. "Some of those cars were real beat up, right? Destroyed, some worse than others—you saw that. Some of them didn't even look like cars anymore. Others looked fine, but they just didn't run anymore. All those broken cars..."

"Lotsa people try to fix them up before they ditch them at the junkyard, you know. But even if they manage to get 'em running again, they're never be the same. No matter what happens, they just end up getting abandoned and smashed into little blocks of

metal." Neil said, cheerfulness fading from his voice. "What do you think would happen if the cars knew that they're just gonna get abandoned and smashed? They'd probably be pretty scared, hmm?"

"Yeah... I mean, I guess so."

"You know how they build cars these days? With shitty engines. I see so many decked out, brand new cars getting scrapped at the yard cuz their insides are mutilated beyond repair. I dunno, I guess those jacked up Mustangs would be mighty terrified if they knew this was gonna happen to them. They'd probably do anything they could to not to be abandoned in the shityard. Because the only reason those kinda cars are made are for everyone to love them. Machines to please people, forced to make others happy and then getting abandoned in the end, no matter how good they did their job—I hate seeing fucking Mustangs in the scrapyard."

"Do you think you're—"

"Hey." Neil patted me on the head, and I felt how badly he was shaking. "Maybe you'll turn out to be a great detective after all, Sherlock."

"You're not broken like those cars, Neil."

"I hate it when you lie. You're a terrible liar," Neil retorted. He hesitated before bluntly stating, "Look, I love people way too fucking much and am terrified to even *think* about when people might be angry with me, or if they don't like me anymore. All I wanna do is make people happy. I work myself into the ground trying to please people no matter what, so they won't be mad at me—I can't fucking handle it when they are."

"Can I ask what made you... worse this time? Does it have anything to do with Carlos?" I risked asking. "I'm sure he's not mad at you. It's been years."

"It's got nothing to do with Carlos. I hardly even remember the guy, alright? Nothing to do with him or anyone else. Just me. It's my fault."

"Why do you think that?"

"I don't wanna talk to you right now." Neil, please. This is something you shouldn't keep to yourself."

"No, no. No. I can't." His voice shook. I was afraid that I had triggered him again.

"You don't get it—I can't talk to you right now. Please don't talk to me."

Time never moved as fast as it did at that moment. Neil stood. Neil fainted. Neil crashed and tumbled off the roof head-first, painting your grandmother's concrete porch red.

<div style="text-align: right;">He loved you,

Lily Wilson</div>

Grad Party

Annie Bowen

My father was obviously confused. He had mistaken Lou's Chicken for Comfort Chicken, but in his defense he rarely ate out, and when he did, he usually ate downtown. He was told that thirty dollars worth of chicken would be plenty to feed the near-fifty guests that would soon be parking their cars all down our road. I was in charge of pizza, not a hard task. Zestos was the best in town, they'd even sprinkle bacon on your crust if you asked them to. So good.

Mom said seven larges should be enough, and not to tip him since he was ten minutes late. Of course, it ended up being Tony Dunnahee from school who delivered it, so I told him to keep the change. "Is today your grad party?" he asked blankly.

"Yeah," I said, and he looked dumbfounded, like I just asked him the million dollar question. "You're welcome to come over when you get off work." I didn't want Tony here eating and talking with my family. I barely knew him, but I hate silence, the way it lingers in the stale air between two people.

"Yeah." He remembered then that he should actually count the money. He pulled the bills from his left hand like they were stuck together with slime, as his brain made sense of the numbers.

I gave up. "Okay. Thanks." I closed the door. *That's why I don't smoke weed*, I reminded myself.

My dad came in with barely enough high-quality, free-range, organic chicken to feed a fat dog. "What the hell is this?" I heard my mom exclaim from the other room.

"Thirty dollars worth of chicken, Lynn." I went into the kitchen and stood by the table like an out of place fire extinguisher. My mom took the container and looked through the plastic lid at the four breaded breasts.

"Jerry, what makes you think that this," she shook the container and jumbled the pieces of meat, "could feed forty-four people?"

"We have pizza, pasta, and dip. And your mom's bringing the cake, right? That's plenty."

"Dip is junk food. You think people are going to fill up on chips and guacamole?" My dad looked at her like he didn't have anything to say, or anything he wanted to say.

"I guess I'll go return it."

Before he pulled out of the driveway, I ran to the car and got in. "Mom said I can go with you," I lied.

"She doesn't trust me to handle it?" He put his arm behind my headrest and looked back as he reversed down the drive. We drove listening to his classic rock station, but when Ramblin Man came on he switched to oldies.

"Where'd you get the chicken from?" I asked.

"The place on Mandel Avenue. Lou's Chicken. Exactly where your mother said to go."

"Dad, that's Comfort Chicken. They sell organic chicken it's like three times the price." He'd been to Comfort Chicken before. He'd been to Lou's too. It was awhile ago, a year or so, but still.

"She should have gotten the damn chicken then, if it's so difficult."

It's not, I wanted to say, but I kept my mouth shut.

At Comfort Chicken we went inside to return the food, and just what I was dreading happening did. "Sir, we don't refund food," the particularly non-hippy looking girl behind the counter informed us.

"Well that's just great," my dad started puffing and shaking his head. "Well that's just fucking great." He lazily tossed the container in the air.

"Dad!" The pieces hit the floor scattering breading like shrapnel as my dad stormed out of the store. "I'm so sorry," I said, putting the dirty chicken back in its container. I didn't know what to do about the breading, so I tried scooping and shoveling it back into the box.

"Don't worry about it, hon." I looked up at the manager whom the other employee must have retrieved. "Go cool your dad off."

"I'm so sorry," I said again and I ran off.

"What the hell, Dad?" I yelled back in the car.

"Hey, watch your mouth," he said, calm again.

"Watch *my* mouth?" He didn't have anything to say, but I just shut up and crossed my arms.

"Hey. Stop," he said.

"Let's just go," I said. he put his hand on my arm.

"Please stop crying."

"Why did you do that?" I asked. "What's wrong with you?" I stared ahead, but in my peripheral I could see him picking at the steering wheel with his thumb.

Eventually, he said, "Look Cassidy," and I knew he was waiting for me turn to him, but I stayed staring out at the plain cinder block wall. "Your mom and I--"

"I know!" I screamed. "Do I look stupid?" Again he was speechless. He'd been speechless a lot lately. "So what, did you cheat on her?"

"No," he said. "God no." I guess I believed him. "Your mother and I, we're just not the same people anymore Not who we married. I know, it sucks. It's going to suck. I went through it when I was your age, and it sucked for me too."

"So did Mom," I said.

"So did your mother," he repeated.

"I don't care, Dad. I don't care. Just take me home. Please."

He started the car and we went to Lou's Chicken. I stayed in the car when he went inside. There was a line almost to the door, and I could see through the window that he was getting irritated, probably thinking about what my mom would say to him when he came back late. I understood why they were getting divorced. They *weren't* happy anymore. I wasn't even happy anymore. I just couldn't figure out why he decided to tell me today. I mean, he ruined my grad party.

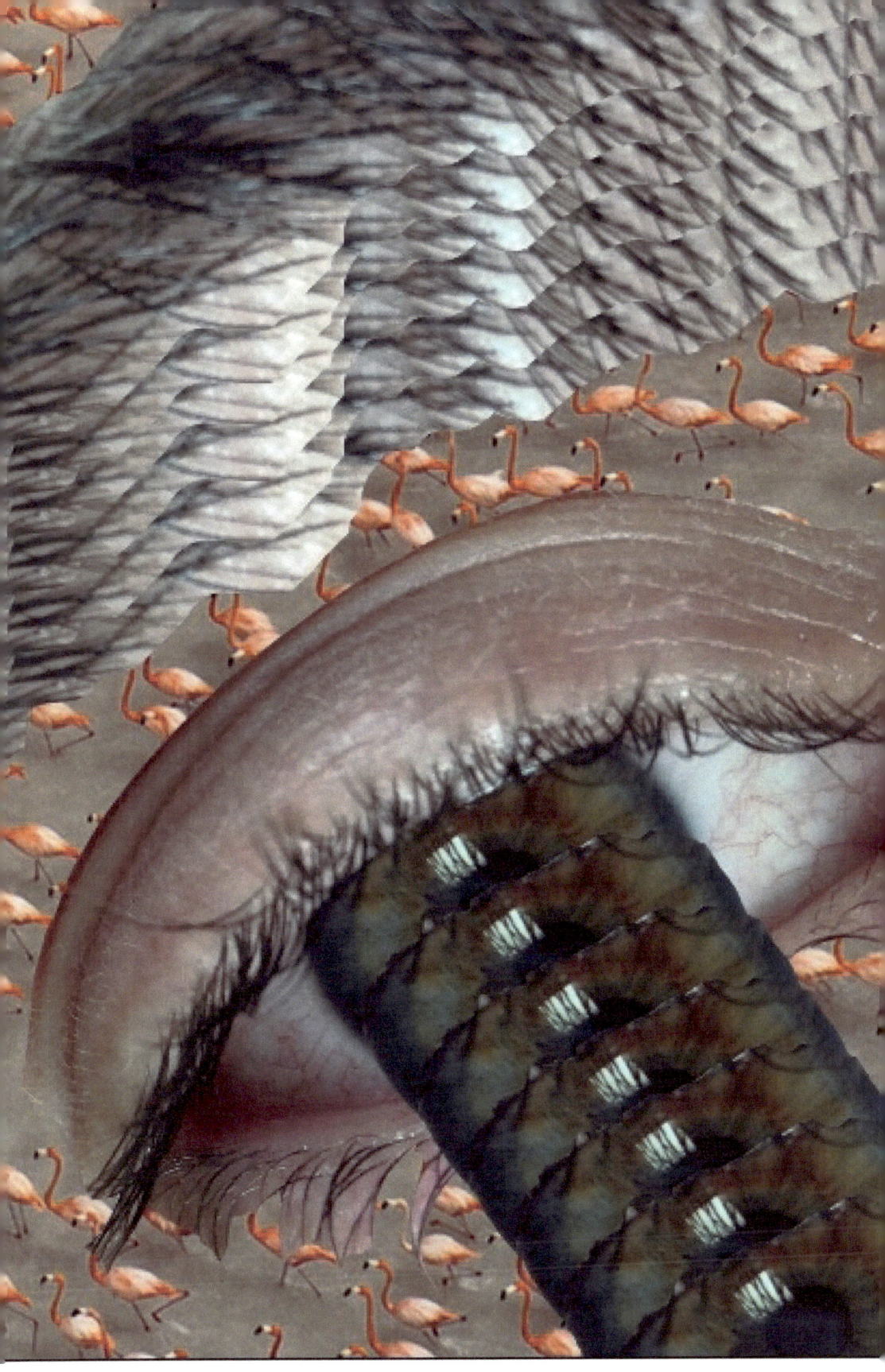

When A Whisper Fell

Christopher Zilwitt

A warm breeze that was an aching bitter wind somewhere far else ceased,

A dew-dropped maple branch budding— halted in its growth,

A stray stopped wandering for a night's abode,

Instead to gaze on into the fading light,

And to ponder for what felt ages longer than it was,

That this was indeed the warmest spot

To die

And The Furnace,

Fiery and white, burning for, how long?

That sweating, brawn men shoveled coal into to keep the flame lit— *ever brighter!*

Froze

The day a whisper fell

Douley's Bar and Grill

Austen Duke

I can't imagine what I'd say to the man to the right of me. He has hair down to his shoulders and a winter cap holding it all tight. He's a little bit younger, maybe forty-five, but any single other thing about him I can't fathom. Sure, I could talk about the Sox. I could talk about the weather, but I'd rather not. "Another, Nick?" Bethany asks.

I nod, "always," and I smile. She smiles back, but I wish that she wouldn't, if it's so excruciating for her to do so. When she can't help but show her white teeth against the black of her mouth, well then I can't either. But when she forces the sides of her mouth into her cheeks to pretend for me the that she's happy, it bothers me in a way I can't explain. She pours the bourbon and it slides along the ice in my glass to the bottom where it rises and warms the cubes to melt and mix with the liquor. The door opens and she averts her focus to the man who comes and stands at the end closest to the entrance. "Beth," I say as liquor splashes my hand.

"Shit." She pulls the bottle away. "A little extra for you," she says. She sets a few napkins on the table and then goes to tend to the other patron.

Ortiz strikes out and the A's head into the dugout for the bottom of the ninth. Bethany asks the guy, "what'll you have?" in a sing-song voice that doesn't know how much he tips and tries not to sound desperate.

"Eighteen-hundred," he says. Commercials remind me of my age-- how everything new speeds on past me like a blur. They're like a hypnotist rocking a pendulum in front of my eyes, but I'm just an old dog too stupid to make sense of it. The ice water's mixed with the Jameson, causing a smooth blend. Not too watery yet. Perfect.

Bethany's staring through the television when the patron at the end taps his fingers on the bar like a poker player and says to her, "another." She pours the rest of the bottle and tosses it. She passes me to grab an unopened bottle from underneath the bar.

"So you're driving the Beetle again?" I ask as she passes me heading back to the man.

She pretends not to hear me as the man puts the shot glass down and she asks, "one more?" with a smile. He smirks in a way that could pass as annoyed.

He drinks the tequila with the same aggression as the first two and then asks, "What do I owe?"

"Thirteen-fifty, hon." He shuffles through his wallet counting to himself, and sets a small stack of bills on the bar. Bethany's shifting them from one hand to the other when the door slams and the man's gone. She counts the rest of the bills, already sure that they're short. I look back up at the television as the game comes back on and I pretend again not to notice that something's gone wrong in her life. "Asshole," she spits under her breath, quiet enough that you had to be listening to hear it, then she slams the register drawer closed. She takes the guy's shot glass to the sink and rinses it. She twists a towel along the inside then the outside and the inside again until the tiny cup shines clear enough for a king's table if only it were edged in gold.

Kimbrel throws an easy one to Semien and he smacks it sailing through the air clear out of the park. The announcers are saying it probably left the stadium. Just then, at the pool table in the corner of the bar, someone chips the cue ball into the side right pocket and starts cussing at the television. It's Danny, and every familiar face in the bar knows he had money on the game. I hide my smirk with a sip of bourbon. I look at

Bethany but she doesn't find a thing funny about a scratched shot or a lost bet. She passes me again. "You're driving the Beetle?" I ask again.

"Jimmy took the truck," she says. She takes a pint glass from under the bar, and studies it in the light as she turns it, then decides it needs polishing. "He took the truck today. He took the T.V. tuesday. He'll take Sam tomorrow."

"He won't take your dog," I say. I don't know Jimmy. I've only seen him come in here once.

"Sure he will, he's his dog too."

"The guy gets the truck, the girl gets the dog." She stops cleaning the glass and looks at me for a second, thinking of how to tell me that I'm wrong. "Rules," I say, and I shrug. She puts the glass back under the table.

"Sure, Nick, the girl gets the dog." A loud clack, then a thunk and a long roll come from the corner. Then another. I look and Danny's putting them away like he's shooting clay pigeons. Finally, he knocks the eight in the far right pocket and the cue ball stops dead where the eight ball lay. I sip my watery bourbon and give my glass a slight shake to clink the ice.

"Another?" I say to Bethany and she pours.

A Clearing

Erika Williams

My father was obviously confused. When he picked me up from school, he started driving in the opposite direction than our house. At first, I questioned him, but he shushed me and told me not to ask questions, so I closed my mouth and turned to face the window, watching the neat city blocks turn to rolling green hills.

I tried not to watch my reflection in the window, tried not to act unnaturally in the presence of my reflection. My father cleared his throat every few minutes and I watched my reflection roll her eyes. I didn't mean to hate my father—wasn't even sure when it had happened—but I found myself resenting even the smallest actions he made, towards me or otherwise.

The trees thickened and I watched birds flit in between branches. I opened my mouth to ask my father, again, where we were going, but just then the car began to slow. I craned my neck, trying to see through the thick woods, but there was nothing but trees.

<p align="center">*</p>

In sixth grade, we were sitting cross-legged on the warm asphalt of the playground, Ally, Sarah, and me, and gossiping about the cute sub we had that day.

"Are you coming over after school?" Ally asked, swatting lazily at a fly.

"I can't," Sarah responded before I could open my mouth. "I'm grounded."

We nodded knowingly. Sarah and her parents were always yelling at each other and Sarah got grounded at least once a week.

"I wish I had cool parents like you, Ally," she said, sighing. "Or just one like you," she nodded at me.

"I hate my dad, though," I said, surprising myself.

"Oh," Sarah said. The three of us were silent for a moment as we watched a group of fifth grade boys play basketball across the asphalt. "Why?"

I shrugged, unsure what to say. Ever since my mom had left, my father had been around every corner. At night, when he thought I was asleep, he got drunk on my mother's wines and I could sometimes hear him crying. I didn't know why, but I blamed him for my mother leaving.

The bell rang before I had to answer.

*

My father pulled into a small, makeshift dirt driveway and motioned for me to get out of the car. I closed my eyes for a small, irritated second before sighing and opening the passenger side door.

He held out his hand as if he forgot that I was a teenager—almost an adult, and not a child. Reluctantly taking it, we walked down the small footpath at the edge of the drive. I realized that the thick wood was thinning out as we walked, and soon we were standing in a small clearing. We stood in silence for a beat before my father held out his arms.

"Like it?" He asked. I looked around, taking in the grassy clearing. Yellow flowers dotted the grass, and if I listened closely, I could hear the faint and occasional skittering of small animals.

"Yeah?" I said, confused.

"Good," My father said, walking to the other side of the clearing. "This is your bedroom."

I turned to look at him, my mouth slightly open. He continued talking as if he did not notice my confusion.

"This will be the bathroom. I'm thinking about one of those showers where the water comes from the ceiling." He moved across the clearing. "The living room will be here. It'll be bigger than our living room that we have now. We can get a bigger tv and another couch, even." As he moved from "room" to "room," I realized my father was going to build this house that he was so clearly describing. I watched as he waved his arms, smiling at times and furrowing his brows when he thought he had miscalculated something. This was something he had been planning. He had mapped out the house, had researched the best materials, the best tools, he had probably meticulously written lists of what he needed and what to do. He had made sure he had a perfect plan before showing me.

I realized I didn't hate my father. As I watched him describe this house that would be years in the making, I felt something in my chest. I thought back on my father's life, or at least the seventeen years I had spent in it. I thought about my mother leaving and the recent loss of his job, and my eyes began to well up. I looked at my father, this man who had given everything for my happiness, and I didn't hate my father.

When he asked me what I thought, I shrugged one shoulder and said, "It's pretty cool."

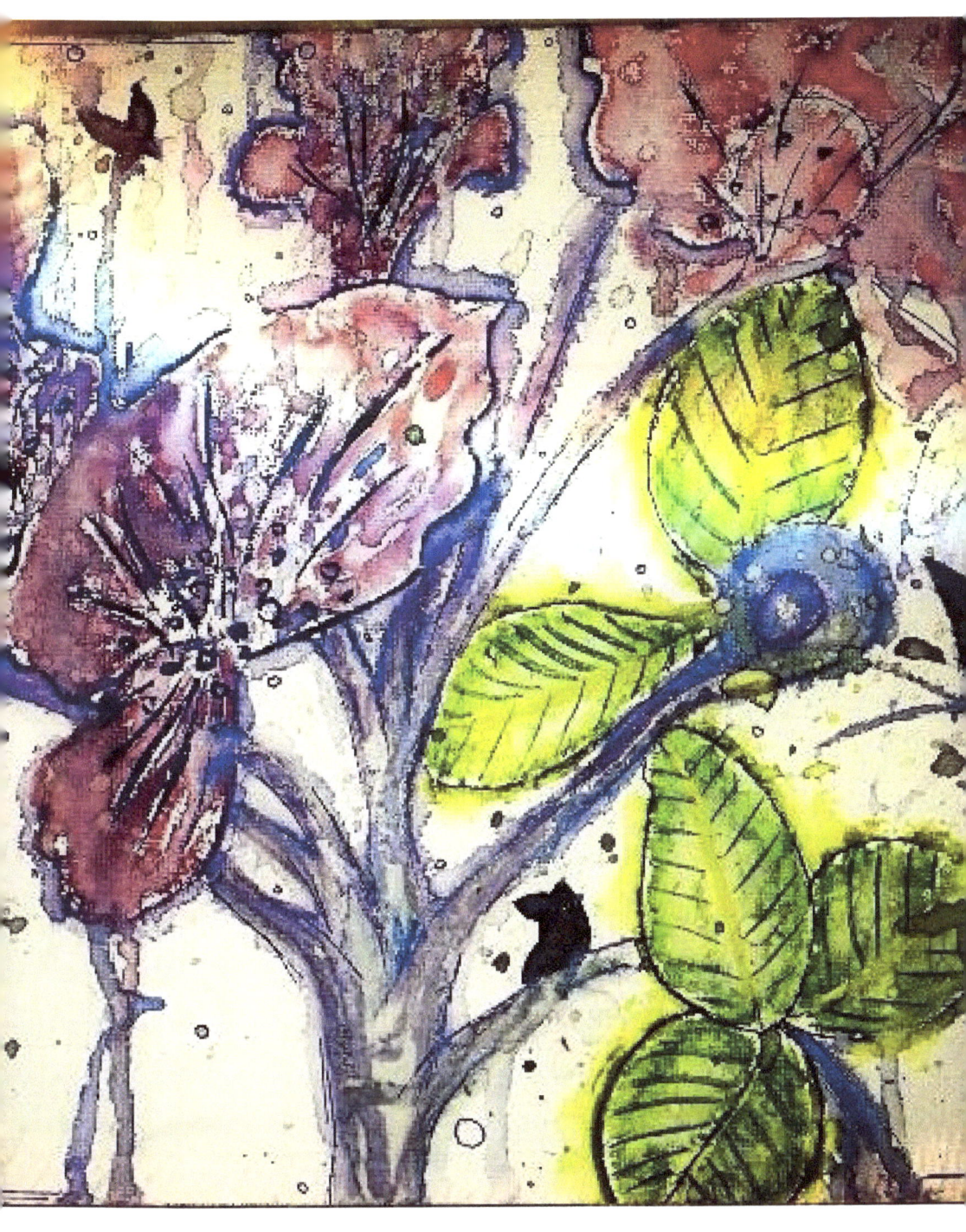

Cadaver
Stephen Bowen

The low whine of the zipper starts

Bated breath, horror

Like peeling back the bandage over some wound

Where one might see sweet healing or putrid decay

At last the shell opened

Like that, the fear is gone

There is no life on the table

But neither is there death

Stripped of even that

Just flesh and skin and bone

It's almost disappointing

But there are the eyes

A mouth

A face

A hand gently curled

Suddenly so much more than just a body

He must be flipped over

And I cannot help but support the head

An odd instinct

To cradle this old man's head like an infant

This thing without pain

Without feeling

Without thought

Yet what he was is not entirely gone

Human

And the force is still there

The connection

Even in the absence of life or death